Creative Quotes

"The Beginning"

By Melissa R. Potts

2015 Melissa Potts. All rights reserved.
ISBN# 978-1-312-74447-9

This book is dedicated to everyone who has pushed me and made me become who I am; my family and friends. Thank you to all my photographer friends who allowed me to enter their artwork in this book as well; they are all notated with their photographs. To all the people who have benefitted from my inspiring quotes; this is for you. Enjoy, share, and be inspiring to someone.

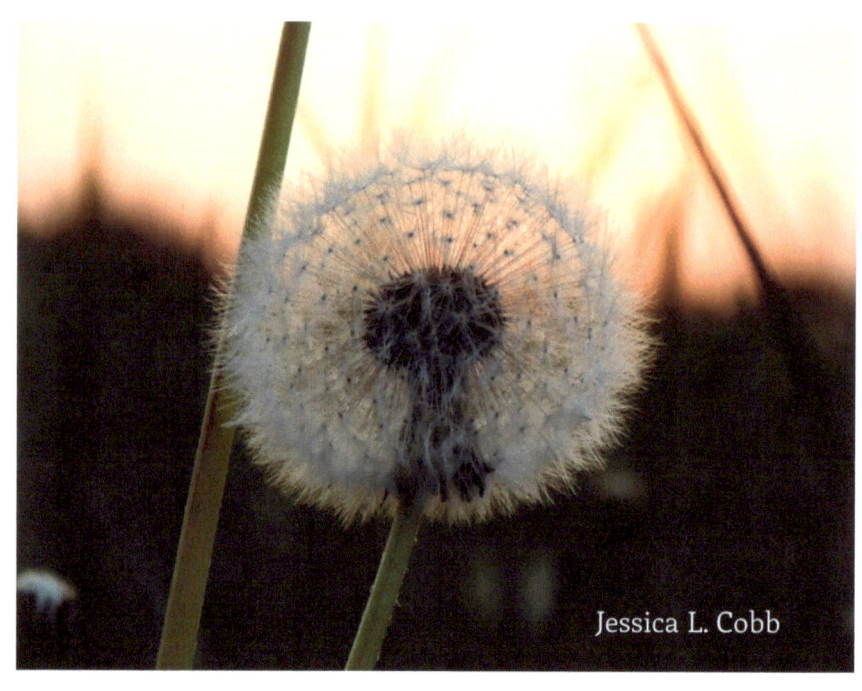

Jessica Cobb of Mom-tography, Frewsburg, NY

Your success is based off of what you do. Your failures are based off of what you don't try, or don't try hard enough at.

It's always better to try and fail than to never try at all. Eventually your failed attempts turn into success as long as you never give up.

Communication is one key to success, but your motivation is how all the keys are found to open all the doors for total success. Never give up.

We have to let go of the things that are holding us back; but first we must figure out what's holding us back. Sometimes it's not so obvious.

Personal struggles also come with personal growth and plentiful blessings; you have to go through it to get to it.

Struggling is that part of life that we all fret, but if we realize the lesson and the blessings to come we fight harder so that the sun may shine again; and it will.

A pity party is an evaluation of your faults, flaws, and everything else you chose not to work hard at. You can stay in pity or you can do something about it. Never allow life's challenges to change you so much that you no longer know who you are.

It is only when you stop the repetitive cycle that things will change. Try a different approach and try to respond differently and see how things become more positive.

You get a second chance at life everyday that you wake up. You can't change yesterday or make up for yesterday, but what you can do is make sure today is better than yesterday and tomorrow is better than today.

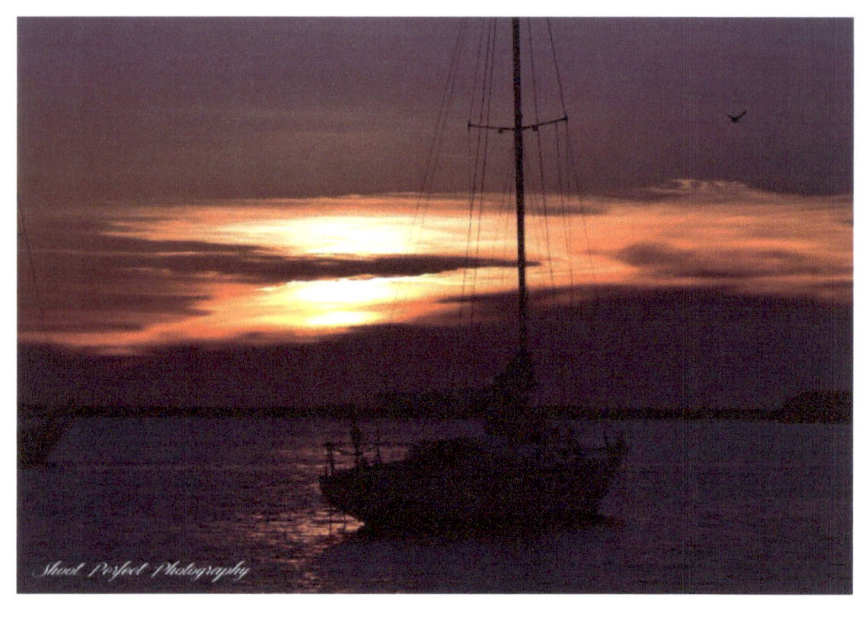

Cassidy Ann Calderon
Shoot Perfect Photography
Bradenton, FL

In the end it won't matter who let you down; it will only matter who held you up. It won't matter who hurt you; it will only matter who helped you. It won't matter who tried to weaken you; it will only matter who tried to strengthen you. Make sure you stay focused on the ones who matter versus the ones who never really did.

You should never give someone your last that isn't willing to give you their first. You will come up empty handed and broken hearted every time.

People come and people go but the ones who touch our hearts and stand the tests of time are the ones we can truly call friends. Do not always be so quick to give someone the title of a friend who hasn't earned it.

Excuses are for lazy people, and mistakes are for people who are willing to try.

Nothing in life is free, with that being said if you got it free; give it back because it may be stolen or worthless.

Wise people take their chances and take their time making choices.

Every minute that you allow someone to steal your joy is another minute lost. Just think of all the seconds, minutes, hours, days, weeks, and years we have wasted being unhappy. Life is too short to waste time on people who keep us unhappy. Try spending more time being positive and spending time with the people who matter the most.

Growing experiences come after the unexpected happens in our lives. That relationship you thought you would never get over; look at how strong you are now and look at the new person who is now by your side. That job you lost and you worried how you would get by; look at the new job you now have. We all go through things in life but always end up better off.

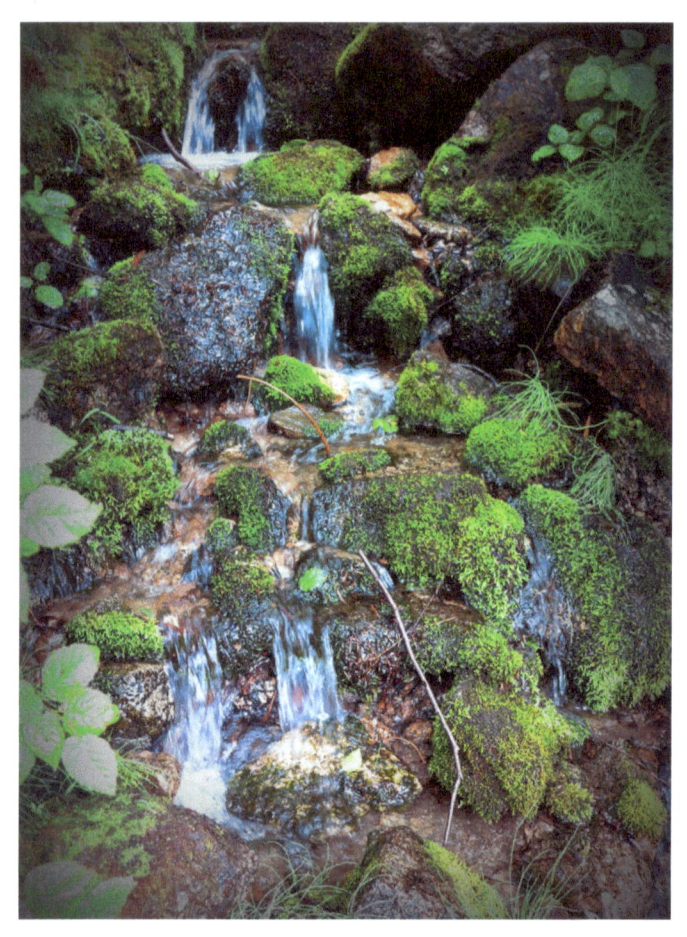

Joanna Jenson
Calgary Photography
Calgary, Alberta

Just remember while you're building that wall to keep people out, you're also trapping yourself behind it. Think long and hard before you build that wall. Is it really to keep people out or to keep you in?

You can put your mind to anything, but it means nothing until you put your heart and soul into it.

Some of the richest people in the world don't even have big bank accounts or thousands of friends. Being rich isn't always what you think rich is!

We need to appreciate the little things in life; we all seem to forget about the less obvious until the obvious is gone or taken away.

Be thankful daily instead of being depressed hourly. Think about what you DO have versus what you don't have.

Nothing holds more value than something you can't hold.

There are three things you can do with ignorance; you can ignore it, justify it, or you can educate it. One thing that you should never do is argue with it.

Ignorance is often ignoring what you choose not to believe. Not because it couldn't be true but because your mind does not have the capacity to think any differently.

Your own ignorance is what enslaves you to continue thinking, acting, and sounding irrational. Opening your mind up to new ideas is how you become more knowledgeable and powerful. Remember there is usually more than one right answer but if there is only one right answer there is always more than one way to get the same answer.

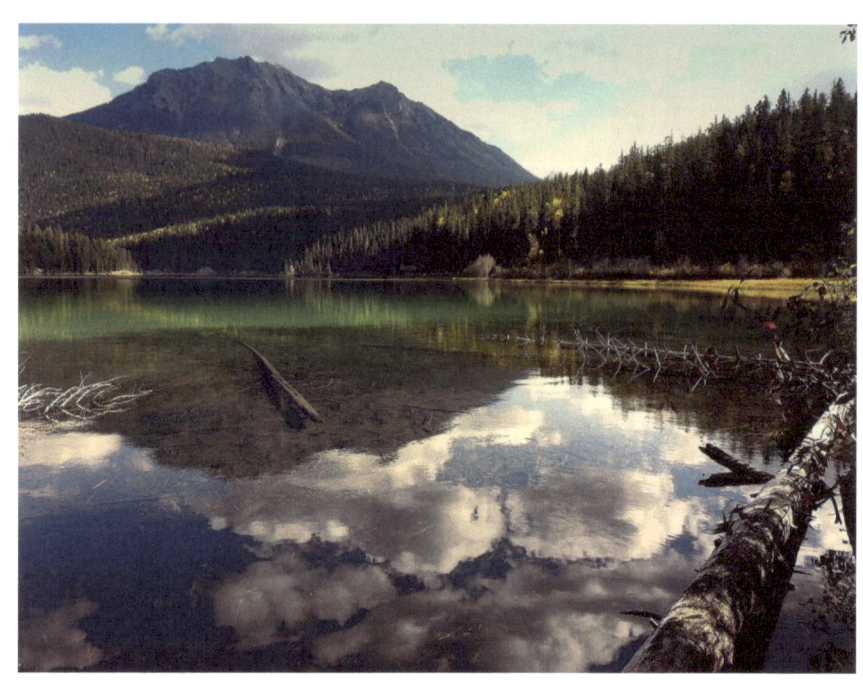

Joanna Jenson
Calgary Photography
Calgary, Alberta

Chase your dreams and see where you end up, or sit idle and go nowhere. You always have to take a risk in order to see growth. Are you up for the challenge?

If you want to be at the top of the totem pole you must first stop being everyone's stepping stone. At some point you have to put you first; no one else will.

I always comes before U……..Always remember to put yourself first or no one else will.

Life and time fly by especially when you're standing still. If you continue to stand still, soon you will stand alone.

There is never really a perfect time for anything; so start now.

Time has always been here and will still be here when you're gone. Learn to appreciate and manage the time you do have. Learn what's important and make time for the things and people on your list.

Don't call on God when all else fails; call on Him first so you don't have to go through so many fails before you get it right.

The devil comes in all forms; be careful who you befriend and who you have faith in. People will always let you down but God will always lift you up.

Just because God does not answer your prayers the way you thought he should does not mean that he didn't answer them with your best interest at heart.

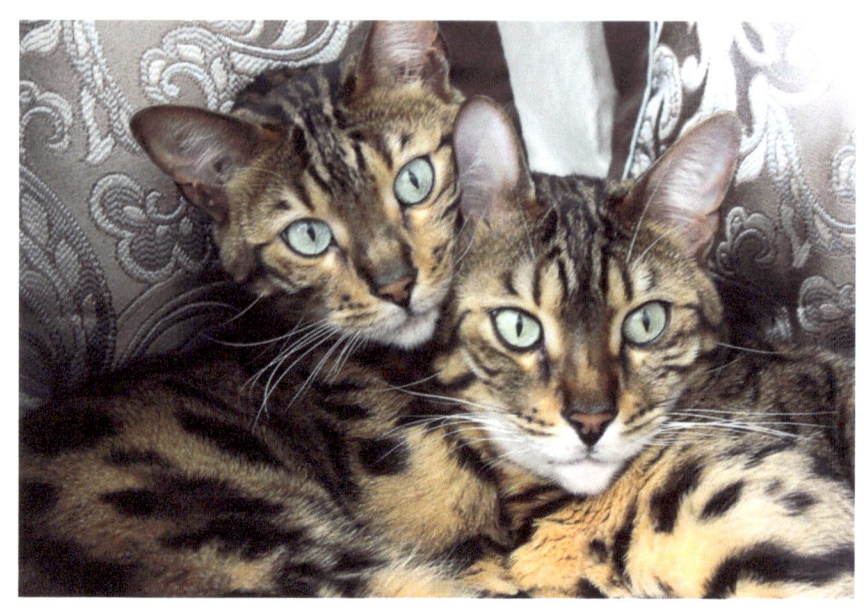

Bill King
"Brotherly Love"
Jasper & Scout
Hudson, OH

You can never truly be happy with someone if you're not truly happy within.

Accepting who you are closes the door on others' acceptance of you.

Self acceptance comes with maturity, growth, and experience. No one can or will accept you for who you are if you don't.

In the beginning we are all without form or substance. It is what we invest in ourselves that makes us priceless or worthless.

One who truly knows themselves knows more than the average.

Self acceptance is the best place to start if you are continually looking at others to validate you; you are the only one who can validate you.

Bear down and hold on tight when life's storms come by; allow them to blow over you not knock you down.

In the eye of the storm of life there is a calmness that can't be explained but it feels good to be able to rest there before going back out into the battle.

Not all battles in life are meant to be won; some battles are to teach us a lesson.

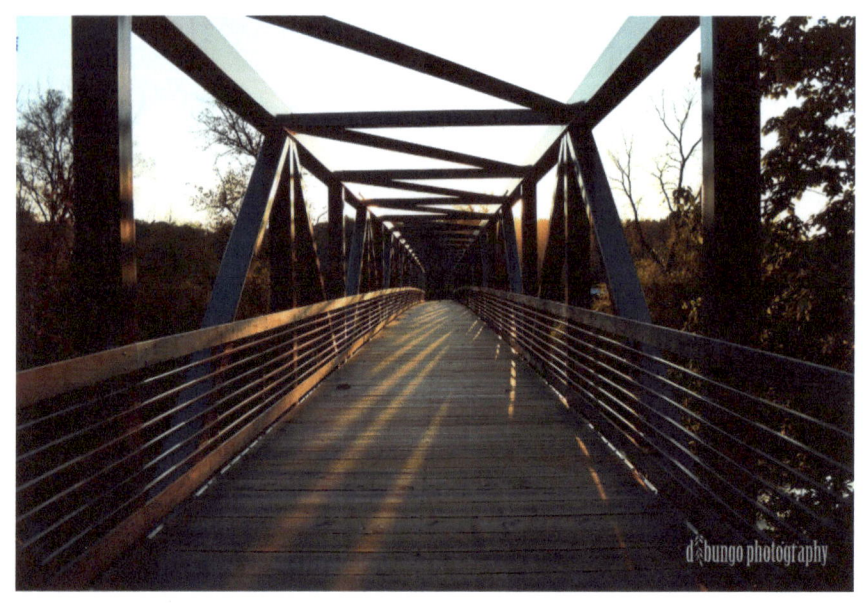

Donna Mohr Bungo
Dbungo Photography
Cuyahoga Falls, OH

Looking back always throws you off track and has you doubting your decision to progress forward; continue to look forward to better and brighter days and that's what you will find.

Imagine if you can the rearview of a car, it represents the past, the car represents the present, and the windshield represents the future. The rearview is so small because the past is such a small part of life, but the windshield is the broader spectrum of what's to come. The future is a bigger and brighter place. Stay focused on what's ahead.

If you're constantly looking back you may end up wrecking your future. Let the past be the past and make a better future.

The devil works in mysterious ways but God works in magnificent ways. A good mystery is good for some but I prefer to have great things magnified.

Just remember that when you openly judge other you are also opening yourself up for judgment; if you cast the first stone of judgment don't be upset when your character is stoned to death.

When you're at your weakest God is at his strongest; when you have given your all he will take over and carry you the rest of the way, but never give up.

There aren't many things in life that are picture perfect. Sometimes we just need to move the picture to see it differently.

Perfection is unattainable; but it's always worth trying.

If something is perfect to you, it does not have to be perfect to the world. It is your eyes and heart that are giving it the label of that perfection.

Perfection is always in the eyes and mind of the one who sees it that way.

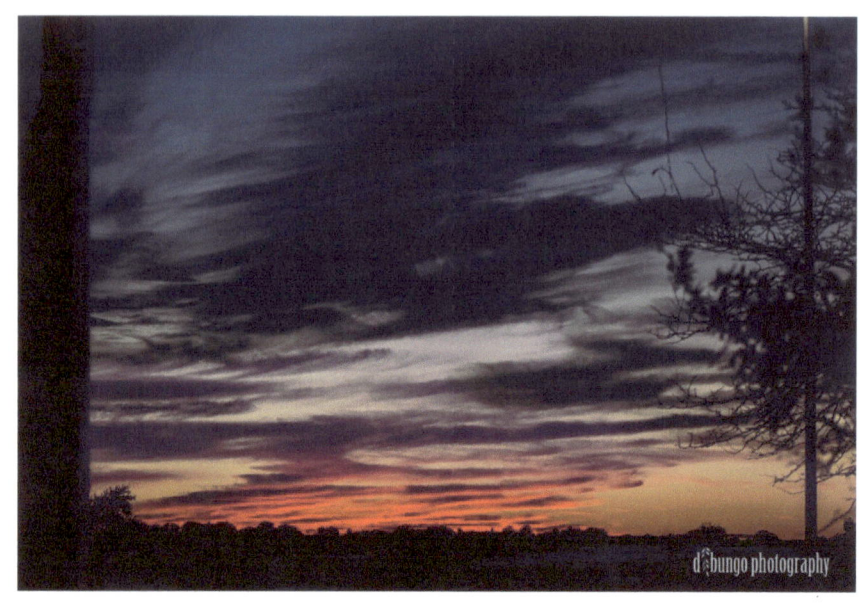

Donna Mohr Bungo
Dbungo Photography
Cuyahoga Falls, OH

Words can cut like a knife or mend like stitches. Choose your words wisely; once they're spoken they can't be taken back.

Sometimes our words can make or break someone's day. It's better to send off positive vibes than negatives ones. If you can't be positive then silence is also a good option.

Don't always be so quick to solve someone's problem when all they wanted you to do is listen. All problems aren't meant to be solved by others, sometimes we have to dig deep and solve them ourselves.

If you think moving on hurts, try staying where you are longer and staying in the pain and when it's all over years down the road the pain will be that much worse. Learn when to let go and when to move on.

Moving on does not always mean leaving something or someone behind. Sometimes we need to open up our minds to the positive side and realize that we need to move on for personal growth.

Keep pushing and progressively moving forward. Eventually things will work out in your favor. If you give up, all hope is lost and all the hard work you did means nothing. Take a break but never give up.

Some people have been hurt so much that they become numb to the pain; they know when they're being hurt, but they are also strong enough to keep moving forward without wearing their emotions on their sleeves.

There are times in life when we have to let go of the person we love to find the one who will also love us back the way we need to be loved; Its painful to move on but it's just as painful to stay when we don't feel that same love we give.

Sometimes we let people go, not because we don't care, but because they don't.

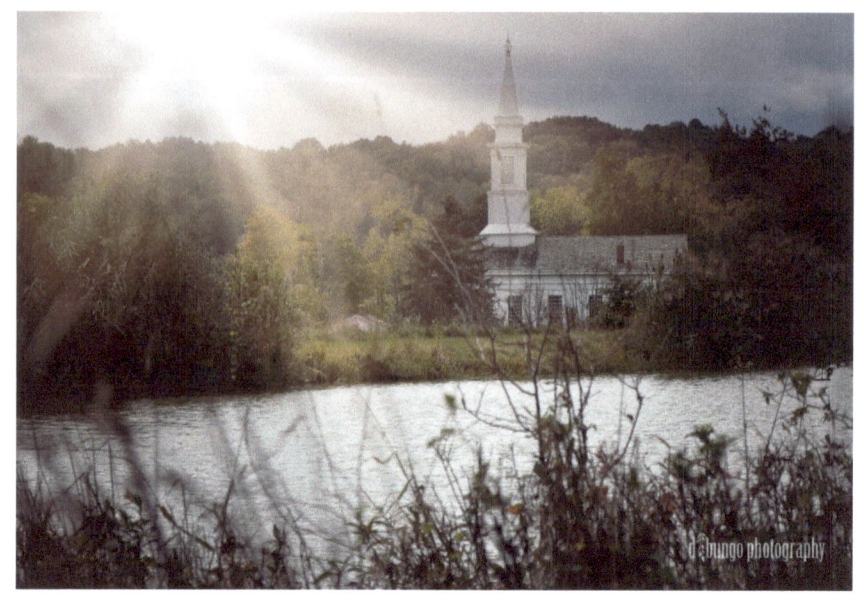

Donna Mohr Bungo
dbungo Photography
Cuyahoga Falls, OH

Don't pray when all else fails, pray so you won't fail. The same way you feel when people only call you when they need something is surely the same way God feels when we do him the same. Sometimes it's ok just to pray to say hello, the same as it is to call a friend and say hello.

On judgment day pray that God does not judge you as harshly as you have judged others.

Today is another day that you were meant to be here; don't take that for granted. Always be thankful even when things aren't going the way you would like them to go.

There are never direct paths to success; you have to make your way through the brush and create your own paths. If success was that easy everyone would be successful.

Being successful takes hard work and dedication, but first you have to start.

Don't waste your time chasing dreams; use your time catching your dreams and turning them into reality.

Start letting go of the things that once made you cry so that you can hold onto the things that make you smile.

A smile sometimes means more than a thousand words. Someone needed that smile today and it doesn't cost a thing to give a smile away.

It's ok to smile thru the pain; sometimes that's how we manage to get by when we're hurting the most.

www.ingramcontent.com/pod-product-compliance
Lightning Source LLC
Chambersburg PA
CBHW041117180526
45172CB00001B/297